ARTIST ARCHIVES™ INTRODUCTION BY MAX ALLAN COLLINS

PORTLAND, OREGON

VARGA GIRLS I

PORTLAND, OREGON

VARGA

GIRLS I

INTRODUCTION

Design Principia Graphica
Technical Assistance Hoover H.Y. Li
Editor Ann Granning Bennett

Printed in China

Library of Congress Cataloging-in-Publication Data
Collins, Max Allan.
 Varga girls I / Max Allan Collins. — 1st American ed.
 p. cm. — (Artist archives)
 ISBN 1-888054-31-X (pbk. : alk. paper)
 1. Vargas, Alberto, 1896–1982. 2.Pinup art — United States.
 I. Title. II. Title: Varga girls 1. III. Title: Varga girls one.
 IV. Series.
 ND1839.V35A4 1999
 759.13 — dc21 99-28117
 CIP

9 8 7 6 5 4 3 2

FOR A FREE CATALOG WRITE TO COLLECTORS PRESS, INC.

P.O. Box 230986
Portland, Oregon 97281
Toll Free 800-423-1848
Or visit our website at *www.collectorspress.com*

TODAY WE USUALLY THINK of Alberto Vargas (1896–1982) as the pre-eminent pin-up artist of his era. The representatives of his estate have even, at times, decried such an appellation as beneath Vargas, apparently considering the term "pin-up" demeaning for such an important artist.

Certainly no illustrator of the twentieth century — not even Charles Dana Gibson — is more associated with the creation of images of beautiful women than Vargas. Through a combination of his own brilliance and exceptional press agentry, Vargas has come to eclipse both George Petty — a household name during the period in which the two artists did their most significant work — and "blue-collar" pin-up master Gil Elvgren, whose images were at least as well-disseminated as those of Vargas.

The artist whose name has become internationally synonymous with pin-up girls (whether his estate likes it or not) was — in the early 1940s — just a gifted illustrator, willing to work cheap, hired by *Esquire* magazine to imitate departed star Petty, who had bolted over pay.

Initially, Vargas patterned his beauties upon those sleek Petty Girls, lounging with their vaguely phallic telephones. Before long, though, Vargas' more delicate and personally distinctive watercolor style emerged. His wide-eyed wonders rivaled Betty Grable and Rita Hayworth as the ultimate pin-up girls of World War Two, leaving George Petty without a high-profile venue and Gil Elvgren toiling in Brown & Bigelow's intentional obscurity.

Alberta was born in Peru, son of celebrated photographer Max Vargas, who trained his son in the use of the airbrush, a tool that would make the artist the natural successor to George Petty. His studies in Zurich and Geneva were interrupted by the Great War, so the aspiring teenage artist immigrated to America in 1916.

His idealized image of a beautiful woman was rooted in Parisian ideals. On a trip as a youth to France with his father, Alberto became inspired by Raphael Kirchner, cover artist of *La Vie Parisienne*. But the fashionably attired office girls he saw in downtown Manhattan encouraged him to combine notions of European romance with an all-American girl-next-door reality. Modern, working women could be just as lovely as a French countess or *Follies Bergère* showgirl — and this was an exciting notion to the young artist.

It now seems inevitable that Vargas should be the illustrator who conspired with stage impresario Florence Ziegfeld to "glorify the American girl." But there were steps in between. First, Vargas toiled as a fashion illustrator and as a freelancer of other forms of commercial illustration. His major break was doing a series of lobby paintings for Ziegfeld's latest production — and a twelve-year relationship began with the master showman, for whom Vargas painted not only showgirls but also comedy stars such as Eddie Cantor and W.C. Fields. During this period he met showgirl Anna Mae Clift, who became his wife and partner for life.

When Ziegfeld took his combination of glamour and comedy to Hollywood, Vargas came along, providing artwork and advertising materials for the film version of "Glorifying the American Girl." While he continued to create Ziegfeld Follies artwork, Vargas began a relationship with Paramount Pictures; throughout the rest of the 1920s and the 1930s, moving his home base to Hollywood, the illustrator created artwork for other studios as well, including Twentieth Century Fox, MGM, and Warner Brothers.

By the end of the 1930s, his participation in a strike ended (for the time being) his stint as a Hollywood advertising and production artist; but then demand for Vargas' artwork came from an unexpected source. The daring, literate men's magazine *Esquire* was looking for a replacement for their superstar pin-up artist, George Petty. Petty's contract was due to expire in 1941 and the robust artist was well aware of the fame of his Petty Girls. He wanted a raise. A big one.

Instead, *Esquire* brought in Vargas to do Petty-style pin-ups. Asked to drop the "s" from his name (perhaps it sounded too "ethnic"), Vargas became Varga and the Petty Girl left the pages of *Esquire*, the Varga Girl taking her place. Considering what a pop cultural impact Petty had made, the fuss was minimal — due in no small part to the mastery of Alberto Vargas.

For five years, Vargas toiled long and hard, creating his definitive pin-ups. If his fame never quite reached that of Petty in those years, his girls were accepted as suitable replacements and — as his tenure included the all-important years of World War Two — put "Varga" into the most prominent position of any pin-up artist of the 1940s. *Esquire* was both popular and prestigious — and Vargas had everything... except payment that could justify the extremely difficult, deadline-crazy work he was enduring.

The pages of this book reveal some of Vargas' best pin-ups of those glorious, difficult years. They also reveal the rather startling difference between Vargas and his predecessor, Petty.

Like Petty, Vargas often used swimsuits, gowns, and negligées to (barely) costume his subjects. And at times, he openly aped Petty — the standard Petty Girl telephone prop, complete with crayon-ish wire, can be seen in the April 1941 calendar image, a rare nude that has nicely varied skin tones but shows Vargas at his most awkward (though the expression on his subject's face is nicely coy).

But Vargas did his best to get away from Petty's pattern, using more variety in his costuming, frequently leaning toward tropical prints, as witness the June 1943 *Esquire* calendar. Though the girl herself is Caucasian as can be, the flowers in her hair and the grass skirt — offset by the brunette's wondrously blue eyes — whisper Hawaii. The blue-eyed blonde of the May 1944 gatefold wears another tropical print, sort of a two-piece sarong whose shocking-pink pattern echoes the flowers in her hair.

What is striking about both these girls — well, there is much striking about both these girls: each is a distinct woman, that is, they are not the same idealized image retreaded into yet another pin-up... a trait too common in pin-up art. Both Petty and Elvgren — Vargas' only true rivals — are guilty of falling into the idealization pattern, reusing the same dream girl again and again, varying her hair color, her apparel, but not her face.

Vargas can be guilty of this at times — another tropically attired brunette (June 1947 calendar image), the yellow of her two-piece sunsuit matching the flowers in her hair — is rather obviously the same subject as the October 1945 gatefold. This particular apple-cheeked, wide-eyed beauty turns up frequently throughout Vargas' career — here she is a dark-haired girl in a somewhat awkward pose, designed to thrust her breasts upward (the flowers at the tips of which none too subtly suggest nipples). That this beauty still seems graceful and dignified, despite the awkwardness of the pose and the questionable taste of her budded breasts, is one of the mysteries of Vargas' art.

Perhaps this sameness reflects a favorite, often used model (Anna Mae herself, perhaps). Nonetheless, Vargas is less guilty of this than any other major pin-up artist; he usually depicts a specific beauty, giving her a personality. The great Gil Elvgren again and again depicted his girls with a kissing pout of embarrassment. The floral beauties mentioned above fall into no such clichéd pattern — the brunette raising a finger to her lovely lips, as if to say "hush," while the blonde, a hand gently poised at her cheek, seems about to blow us a kiss, her eyes narrowed in an expression of warm romantic love, and the bosom-thrusting brunette gazing with a clear-eyed, nonsalacious affection at some lucky off-stage lover...

Vargas' favorite prop is the large, floppy hat. Perhaps because each beauty has such limited apparel, Vargas chose to use oversize bonnets to give him a secondary area of color and texture that would not in any way obstruct the charms of his subjects. Additionally, the shapes of the hats — often circular - provided another design element, since his pin-ups (like Petty's) lacked a specific background, even the solid color and library of props of which Elvgren and his followers made use.

In his August 1941 calendar image, Vargas uses a circular, round, mostly sheer hat as the only covering one of his rare *Esquire* nudes, a diagonally-depicted, stunning blonde whose long golden tresses are arrayed in an unkempt manner that gives the sophisticated girl a hint of the animal.

His sarong-style beauties weren't Vargas' only effort to get away from the swimsuit/negligée/gown trinity. He pioneered the use of cute, sexy, if not terribly sensible outfits — witness the stunning blue-eyed blonde sailor girl of his April 1945 gatefold; or his radiantly beaming cowgirl of March 1944's gatefold. I'm not sure what the radiant redhead of the March 1946 gatefold is wearing — it's yellow, and ruffled, and perhaps is a maid outfit — though I'm quite certain no one wrote *Esquire* to complain.

Exercise outfits and sunsuits — always designed more for eye appeal than practicality — are frequent Vargas fliers. The blue-eyed blonde — another specific beauty —of the February 1946 gatefold seems to be caught in the midst of a sit-up, which is completed by the swimsuit-like clinging outfit of the redhead of the March 1947 calendar. Neither looks to have worked up much of a sweat, though the same might not be said for some *Esquire* readers.

Not that Vargas was a disappointment when his girls wore more traditional pin-up and glamour apparel. We have chosen for the cover of this book a graceful brunette, shoulders bare, expression romantically distracted, with the characteristic flowers in her hair, their violet-pink hue picking up colors on the scarf at the woman's wrist. The brown-eyed platinum blonde of his September 1945 gatefold is one of Vargas' most famous images — the combination of lush curves peeking through the sheer fabric, the bold outline of nippled breast, with the wholesome, apple-checked beauty of a face that is at once naughty and innocent, sums up the appeal not only of Alberto Vargas but of the American pin-up in general — at its best, anyway.

Though the *Esquire* years ended acrimoniously — the magazine treating Vargas no better than Petty — these were the golden years of Vargas' work, the body of work for which he will be most remembered. Vargas did the near impossible: he was able to step in and fill the shoes of a popular culture superstar like George Petty, only to eventually surpass him in the public's eye.

Only an artist with the technical skills and the poetic soul of Alberto Vargas could have done so.

Sources: *Varga: The Esquire Years*, edited by Reid Stewart Austin, Alfred Van De Marck Editions, 1987; *The Great American Pin-Up*, Charles G. Martignette and Louis K. Meisel, Taschen, 1996; *Varga*, Tom Robotham, Smithmark, 1995; *Varga*, Tom Robotham, BDD Illustrated Books, 1991.

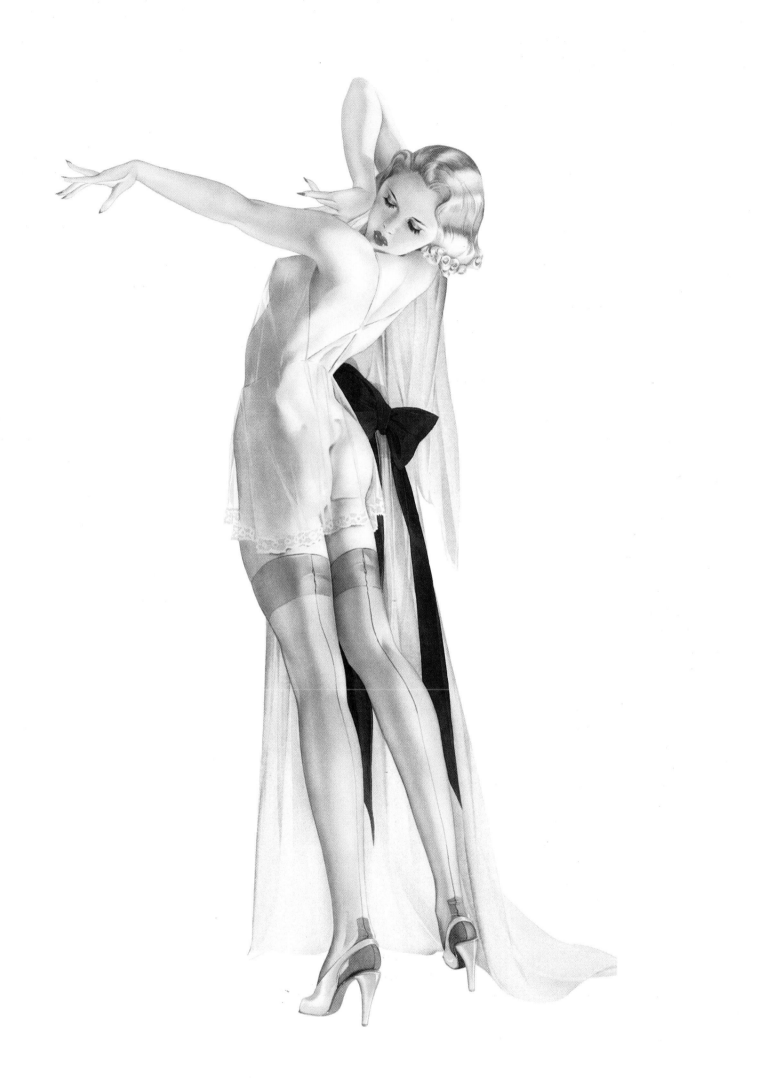

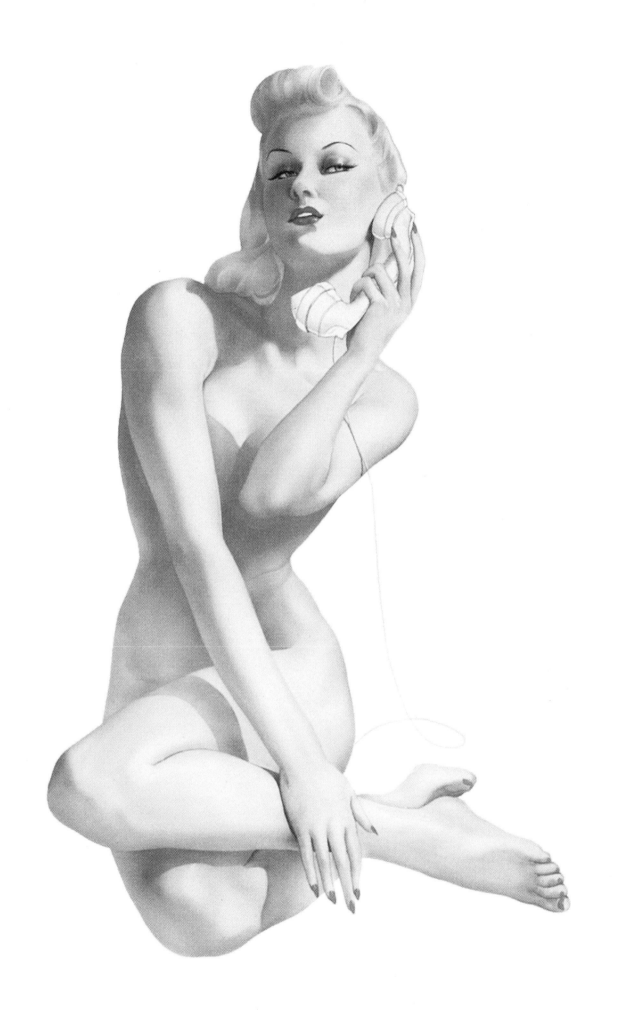

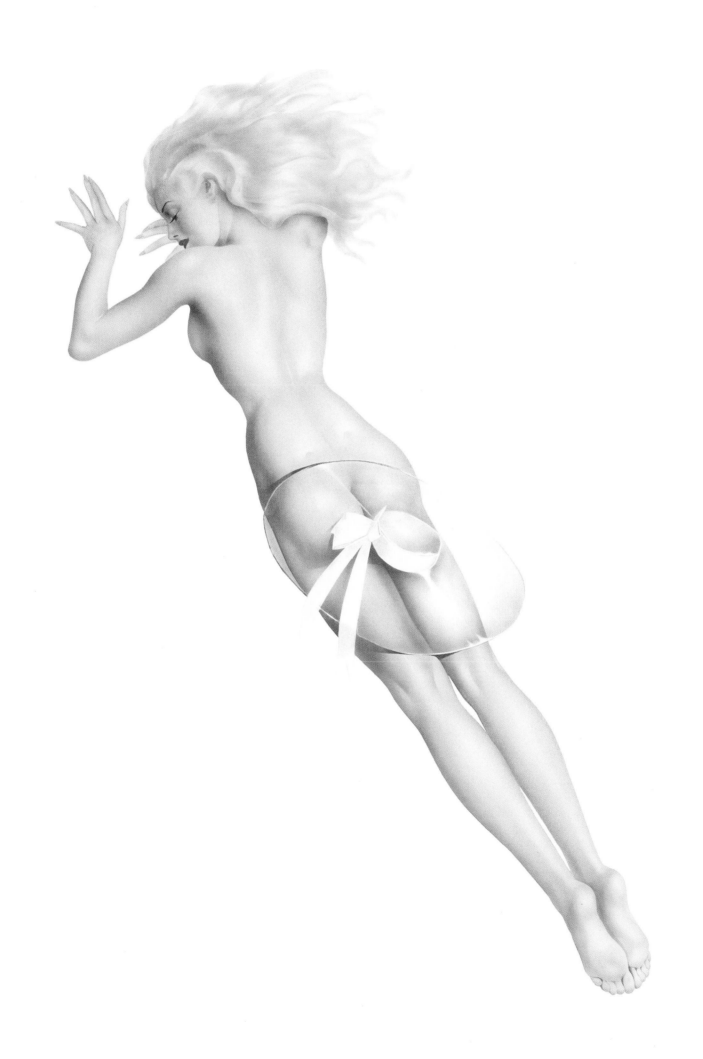

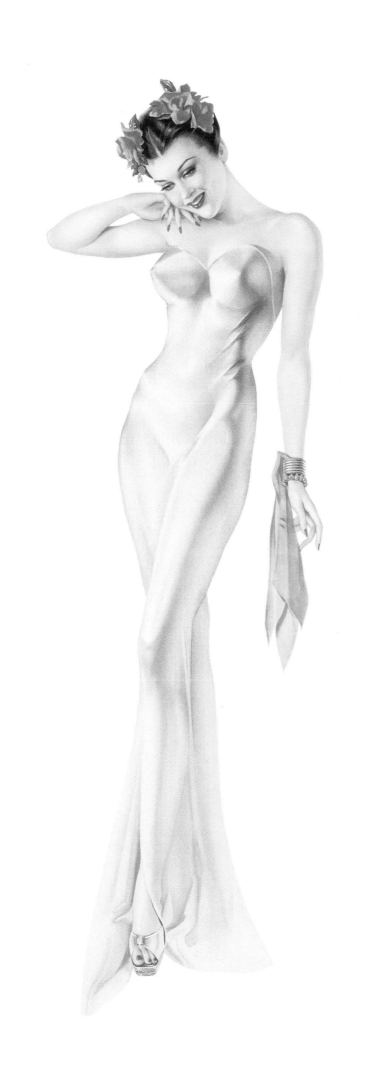

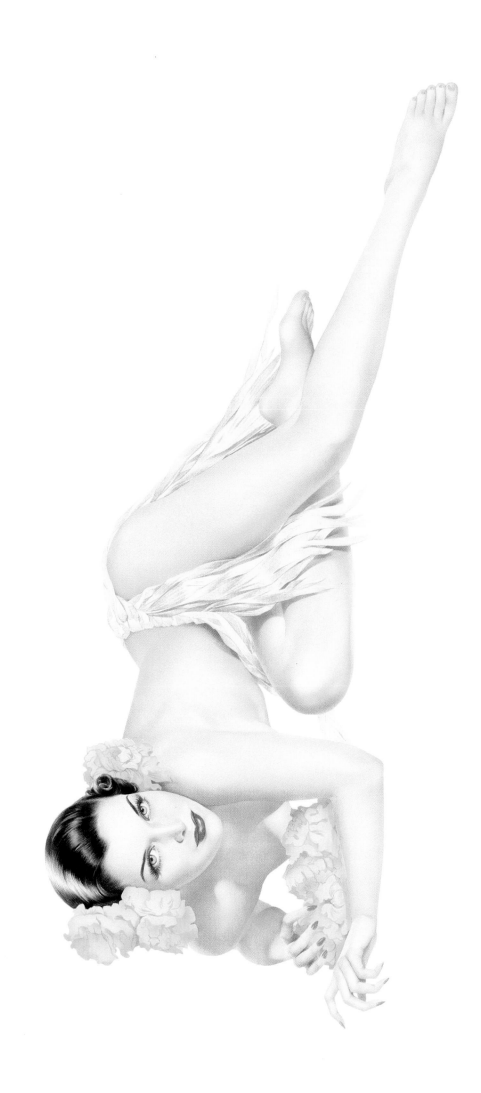

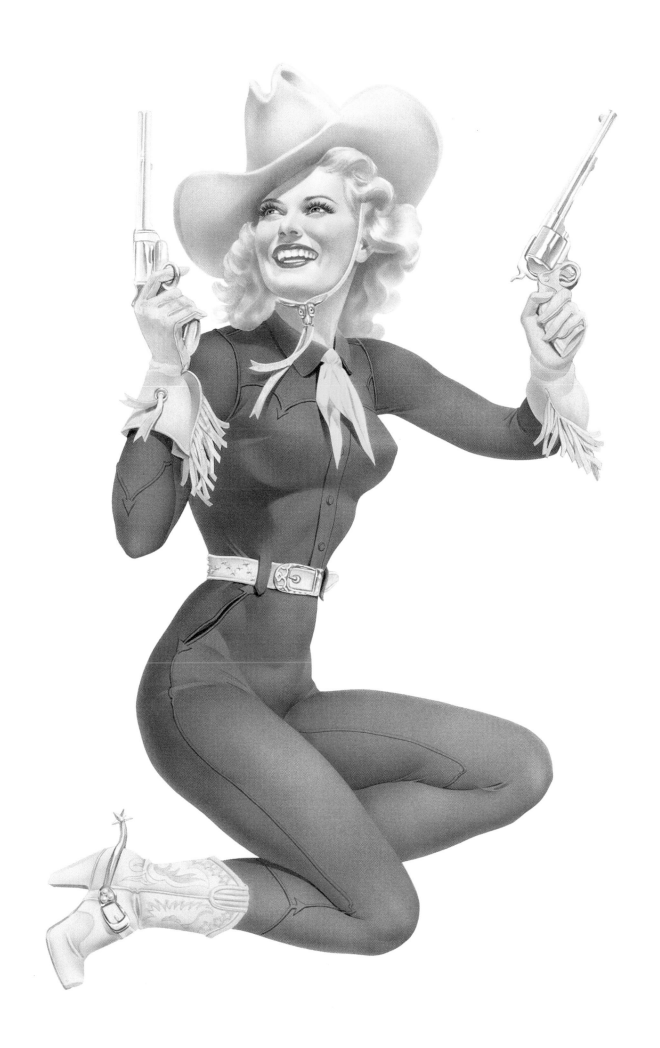

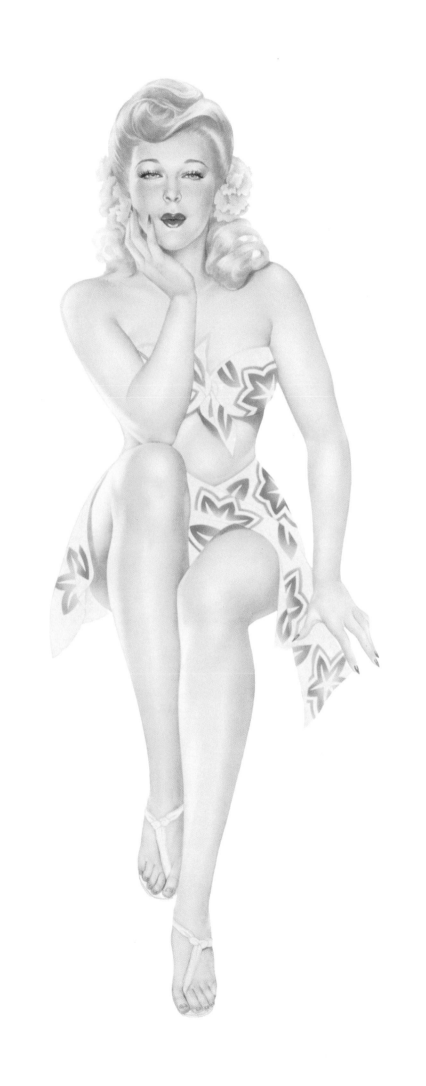

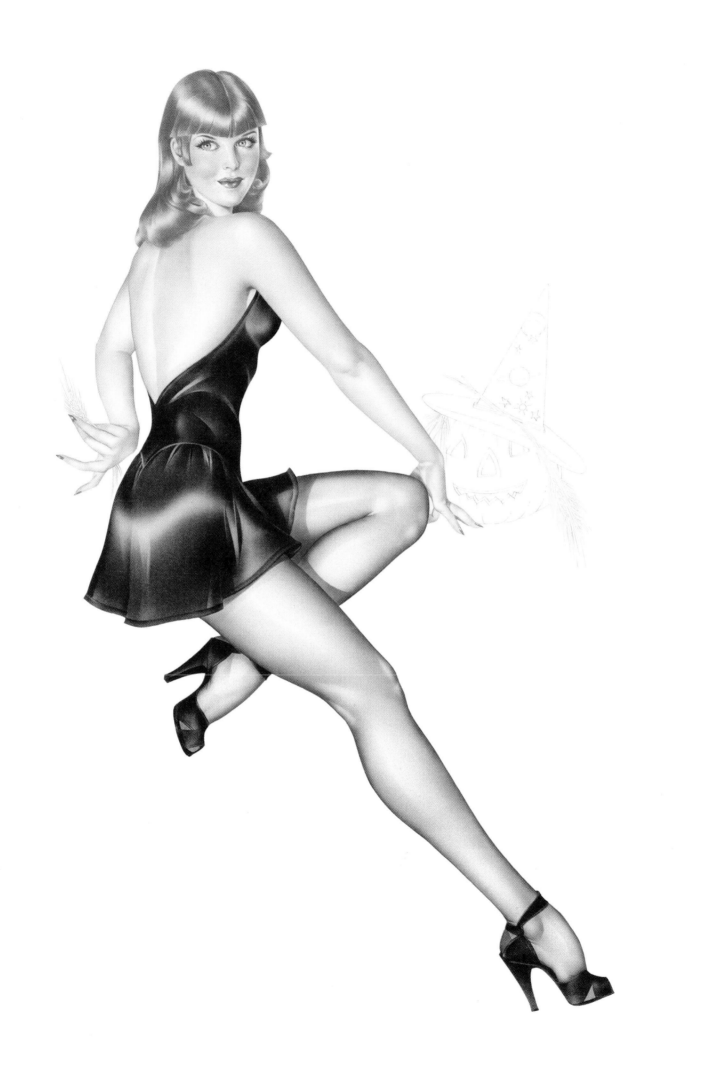

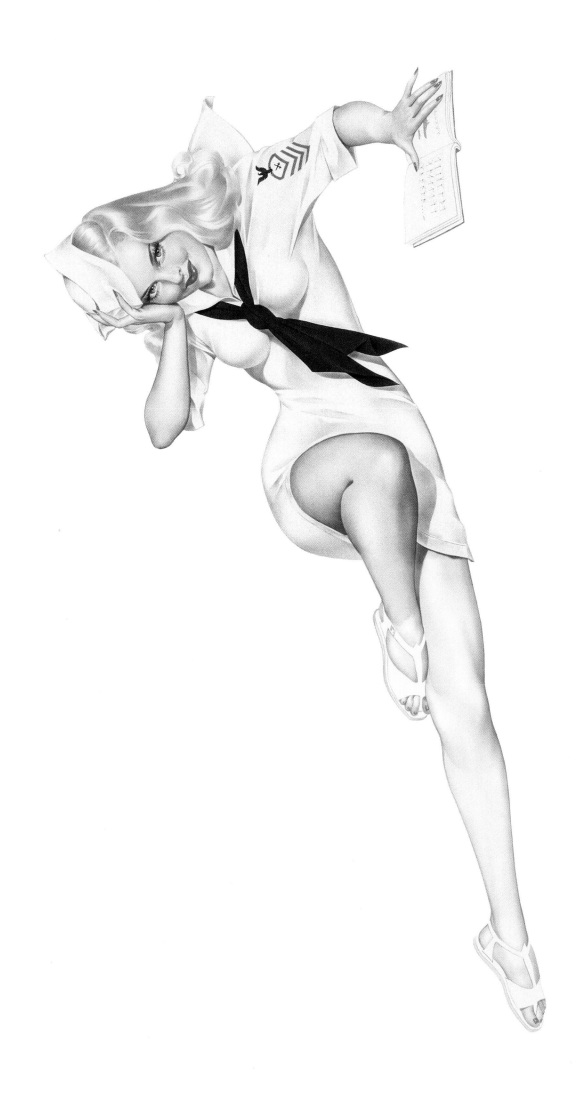

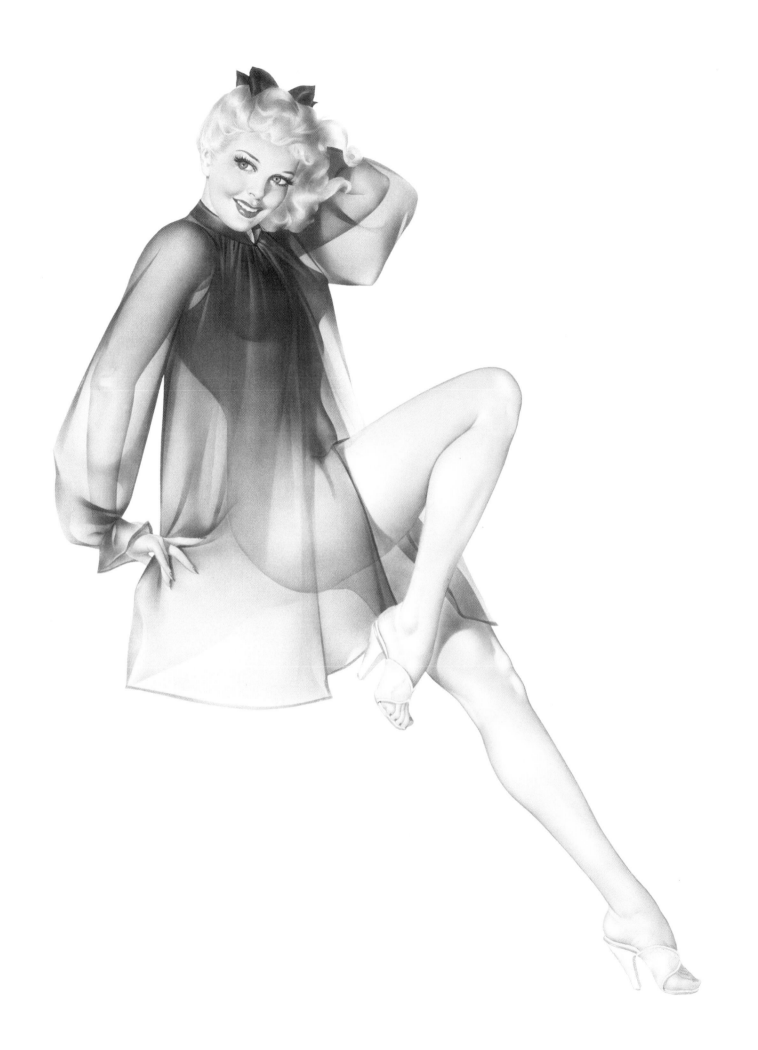

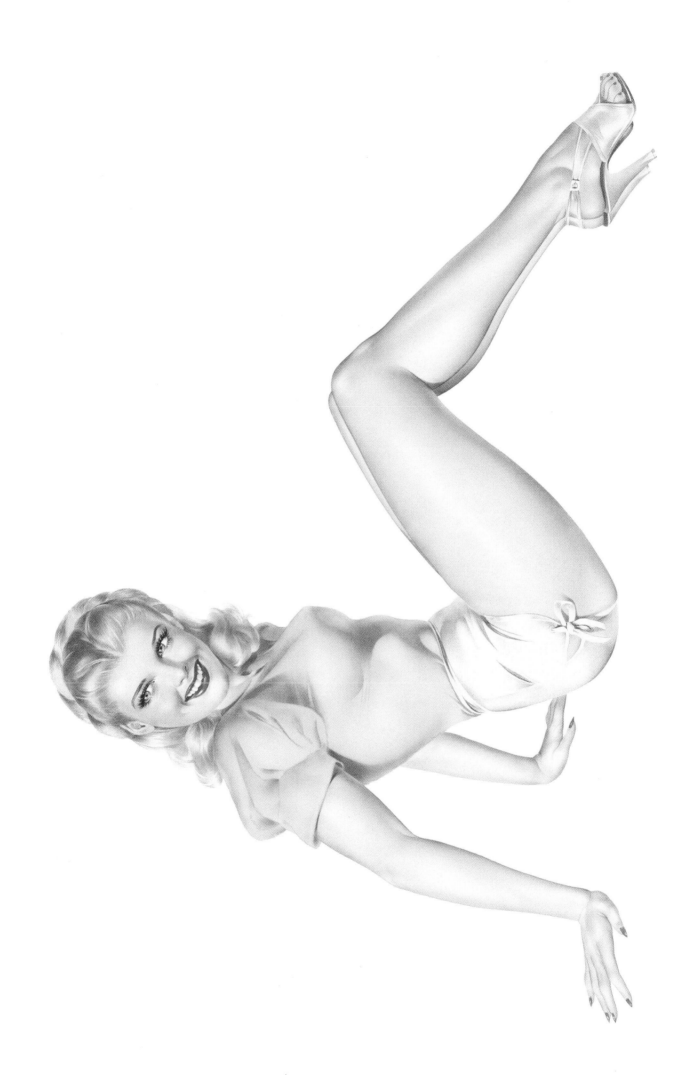

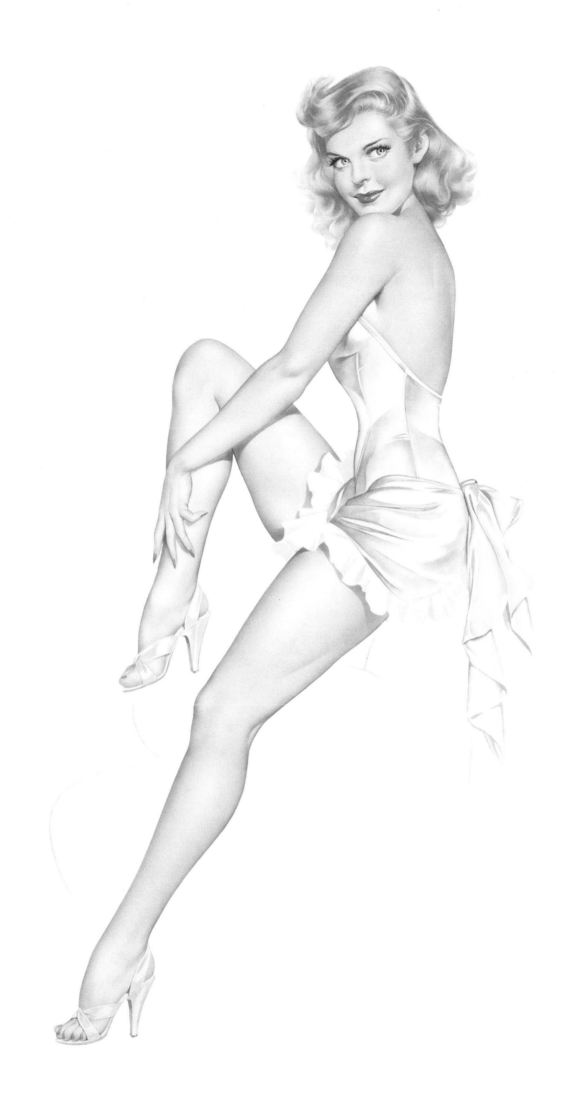

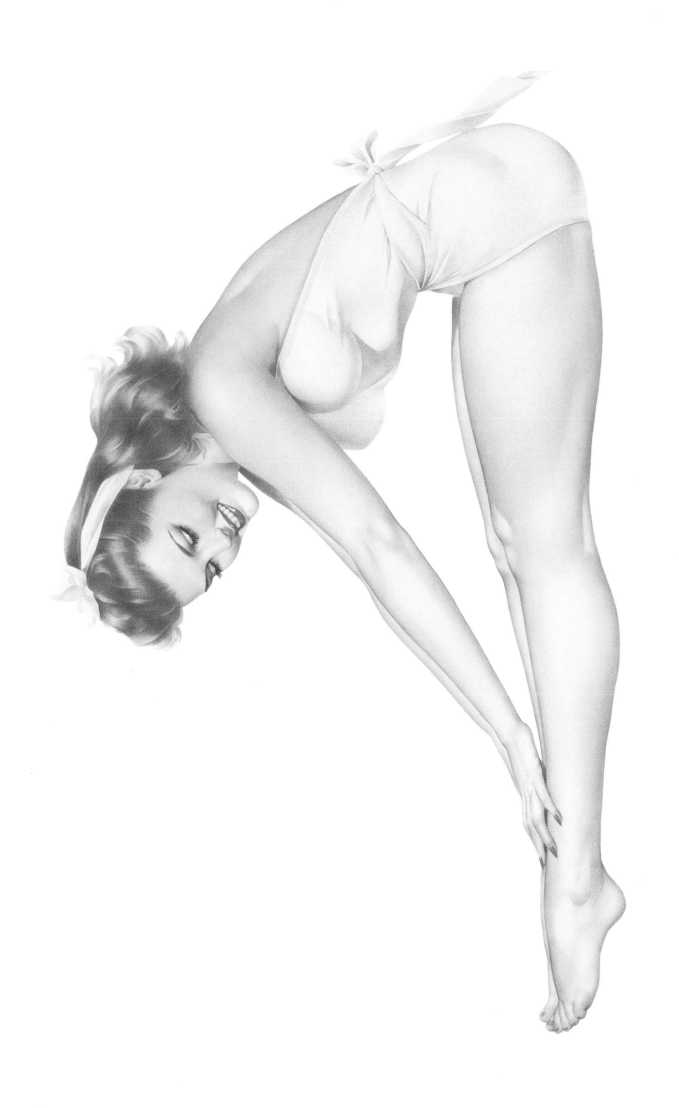

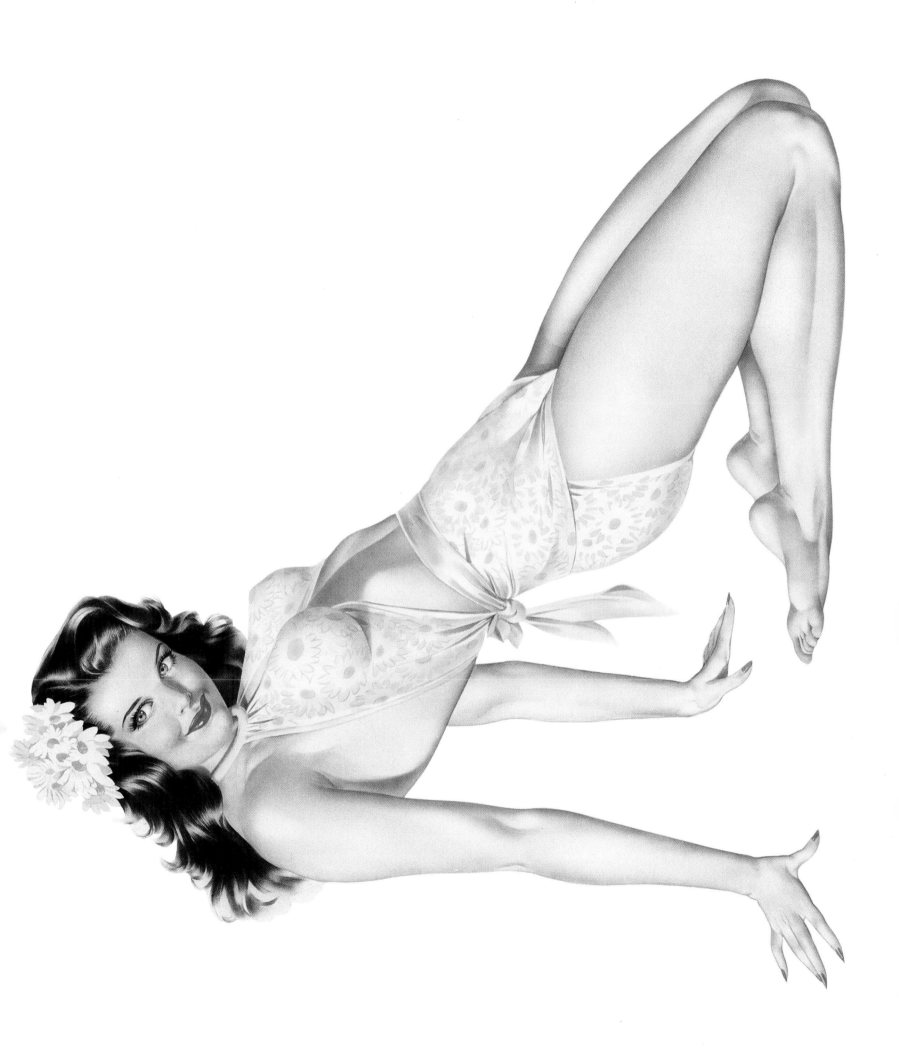